M. DEGAS STEPS OUT

M. DEGAS STEPS OUT

an essay

PHILIP HOY

WAYWISER

First published in 2022 by

THE WAYWISER PRESS

Christmas Cottage, Church Enstone, Chipping Norton, Oxfordshire, OX7 4NN, UK
6419 Cedonia Avenue, Baltimore, MD 21206, USA
https://waywiser-press.com

Editor-in-Chief
Philip Hoy

Senior American Editor
Joseph Harrison

Associate Editors
Katherine Hollander | Eric McHenry | Dora Malech | V. Penelope Pelizzon
Clive Watkins | Greg Williamson | Matthew Yorke

9 7 5 3 1 2 4 6 8

A CIP catalogue record for this book is available from the British Library.

ISBN 978-1-911379-11-9

Printed and bound by
T. J. Books Ltd., Padstow, Cornwall, PL28 8RW

for Nicholas Garland

"What is the past, after all, but a vast sheet of darkness in which
a few moments, pricked apparently at random, shine?"
— John Updike, "The Astronomer"

"The past is a country that issues no visas. We can only enter it illegally."
— Janet Malcolm, "Six Glimpses of the Past"

1

In the autumn of 2011, I went to see *Degas and the Ballet*, an exhibition which had recently opened at the Royal Academy in London's Piccadilly. Long an admirer of Degas's art, I cherished this opportunity to see so many of his works – not far short of one hundred paintings, sculptures, pastels, drawings, and prints, as well as a number of the photographs he had taken in his later years.

Although the exhibition was everything I could have hoped for, and more, my most vivid memory is not of the works on display, but of a grainy sequence of black and white film which was being shown in the exhibition's last room. The sequence was very short, running for a mere nine seconds, but it was being played on a continuous loop, and I sat and watched it again and again, totally mesmerized. A notice to one side explained that the central figure in the sequence – a bowler-hatted man walking along a busy Parisian street, accompanied by a much younger woman – was the artist whose exhibition we had just visited. I don't recall if it said anything else.

After my visit to the Academy, I was able to find the same sequence online, where it is introduced by the man I now learned was its maker – the celebrated French actor, director, screenwriter, and playwright, Sacha Guitry.[1] The sequence was evidently one of several Guitry had filmed – his other subjects were André Antoine, Sarah Bernhardt, Anatole France, Octave Mirbeau, Claude Monet, Auguste

Renoir, Henri-Robert, Auguste Rodin, Edmond Rostand, and Camille Saint-Saëns – and then put together as a film entitled *Ceux de chez nous*. The film had its first showing in Paris in November 1915, when Guitry was 31 years old, but the version I found online, which was assembled in 1952, included footage of the then 68 year-old Guitry newly introducing each sequence.[2]

In his introduction to the Degas sequence, Guitry says nothing about its provenance. After admitting that he hadn't known Degas personally, and that, unlike his other subjects, all of whom had consented to being featured, Degas had to be filmed surreptitiously while he was out and about, the rest of what he says is given over to praising the artist's work.

Once I'd downloaded it onto my computer, I found myself no less fascinated by the footage. Indeed, I started to play around with it, first by slowing it down to a quarter of its proper speed, and then by breaking it up into over 250 stills. I wanted to extract as much information from it as I possibly could. Starting with the first, and ending with the last, 42 of the stills are reproduced below.

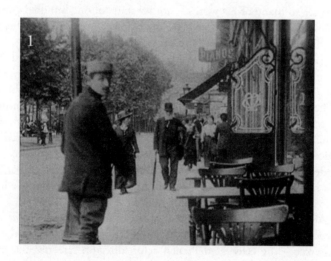

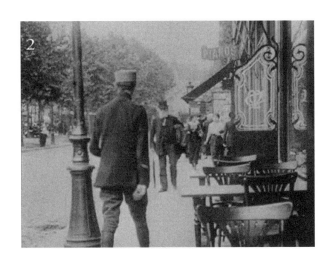

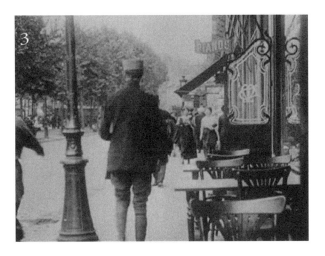

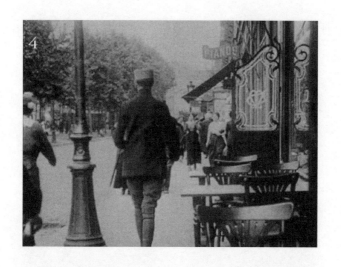

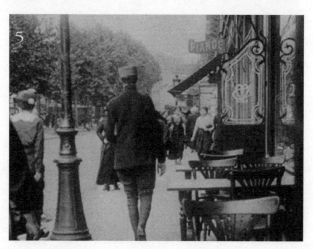

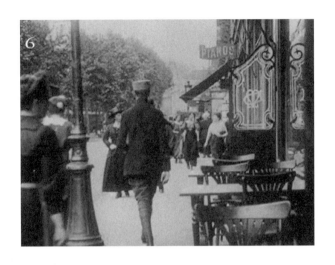

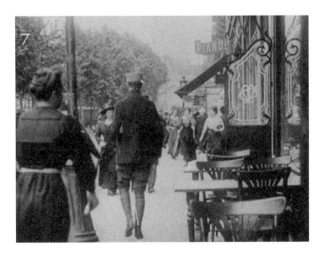

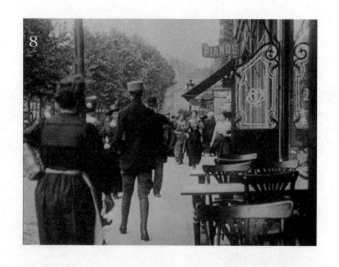

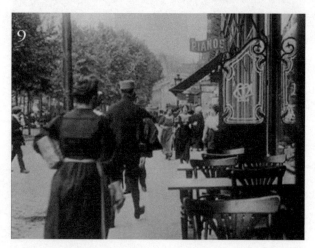

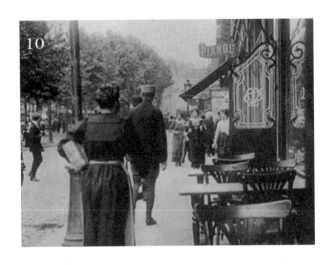

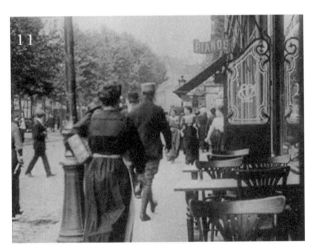

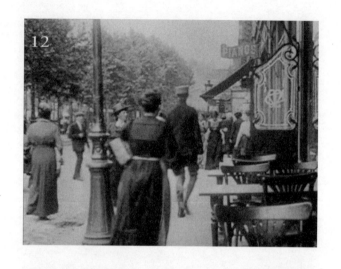

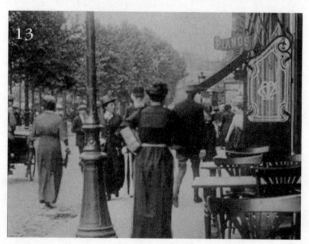

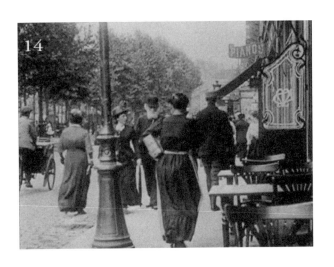

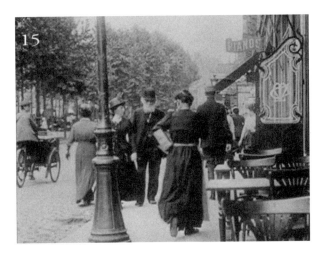

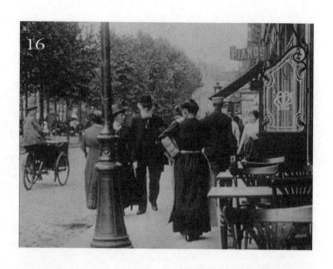

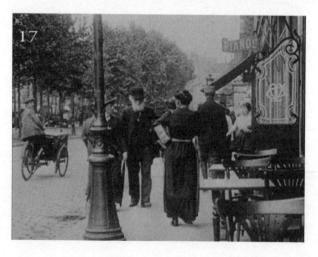

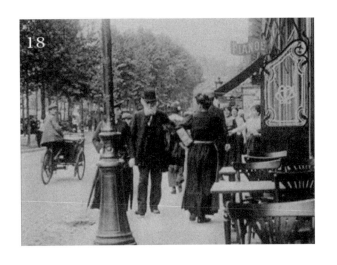

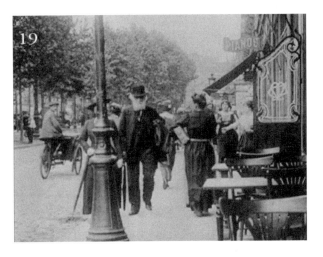

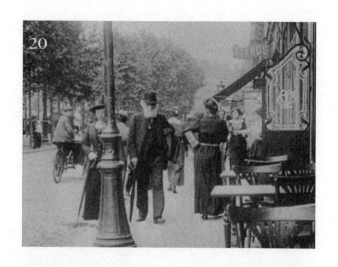

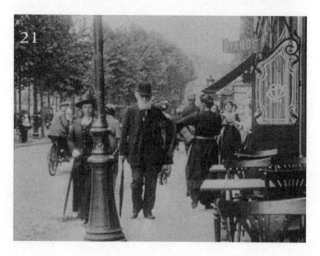

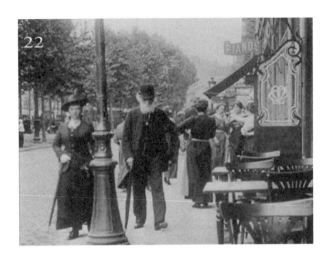

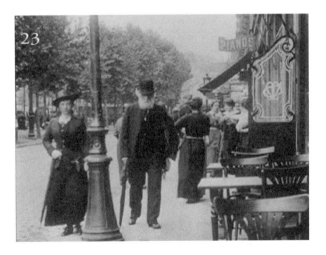

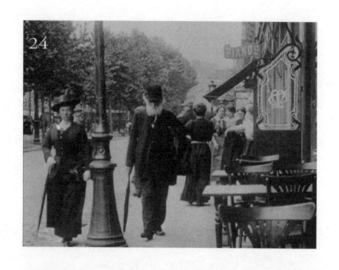

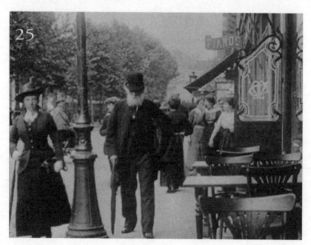

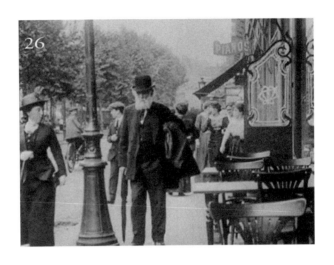

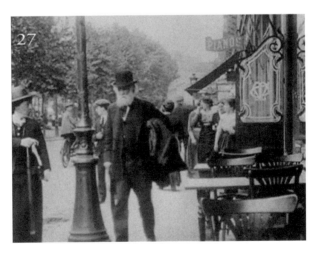

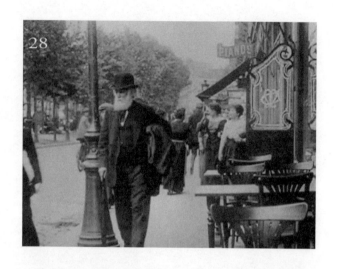

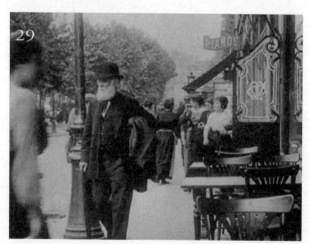

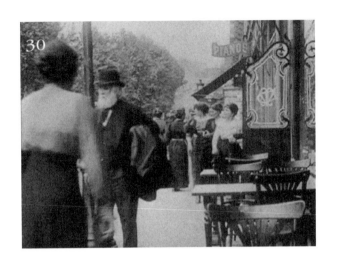

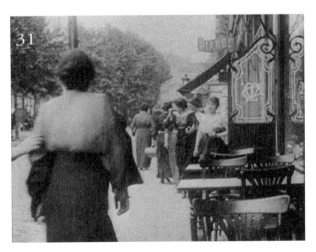

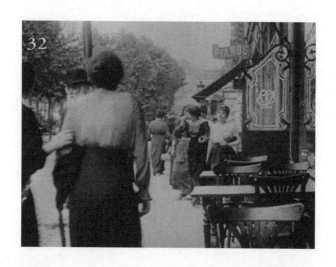

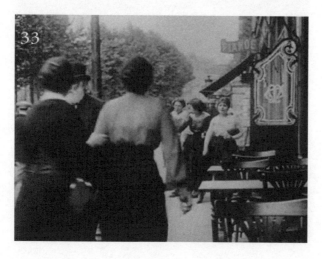

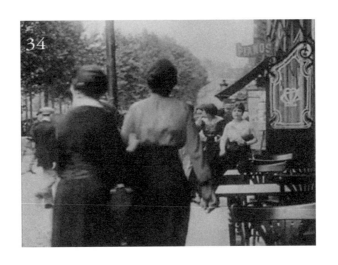

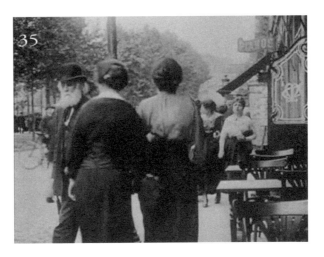

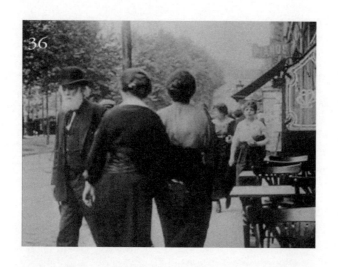

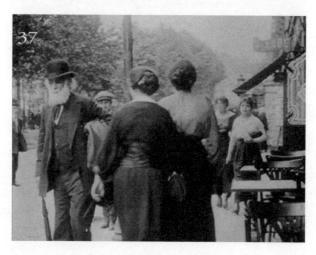

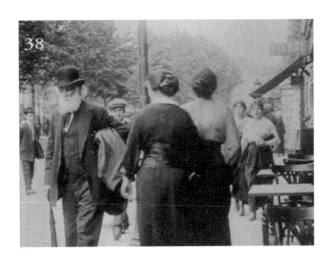

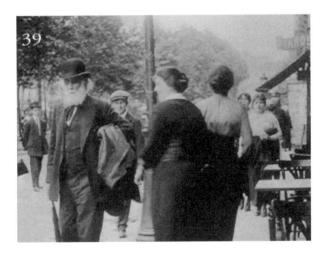

27

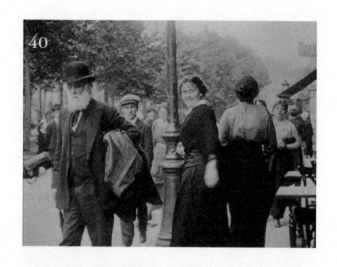

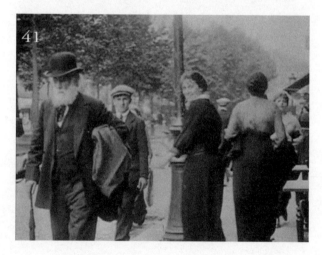

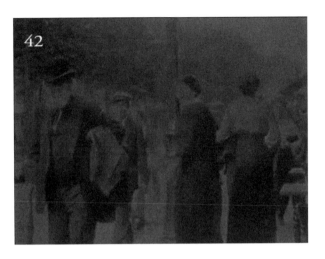

42

2

Curious to find out more about this bit of film, I ordered copies of two out-of-print books – Roy McMullen's 1985 *Degas: His Life, Times, and Works*,[3] and James Harding's 1968 *Sacha Guitry: The Last Boulevardier*.[4]

The first of these bore out what the estimable Francis Steegmuller said about it on the dust-jacket – that it is "an unusually perceptive biography", one which "celebrates with equal skill Degas's subtle, complex personality, the variegated beauty of his work, and the cities … that he knew" – but although it numbers among its many illustrations a still from *Ceux de chez nous*, that still is unattributed, and there is no discussion of it, or of the film from which it was taken, anywhere else in the book.

Harding's much shorter book proved to be more helpful. The opening four pages of its eighth chapter are largely devoted to the film, telling us how it came to be made, and saying something about its various sequences, including the one devoted to Degas.

According to Harding, *Ceux de chez nous* had its origins in the

French nation's exposure to some of Germany's early wartime propaganda:

> A group of German intellectuals had issued a manifesto at
> the beginning of the war that had deeply irritated Sacha.
> By way of patriotic reply he decided to make a film which
> would show some of France's greatest men in the arts.[5]

Harding doesn't tell us anything more about the manifesto, but it wasn't difficult to establish that it was originally published in the *Berliner Tageblatt* on October 4th 1914, just two months after Germany had declared war on France, and was entitled *An die Kulturwelt: das Manifest der 93*. It had been organized by the German poet and playwright, Ludwig Fulda, who had persuaded ninety-three of his fellow countrymen – scientists, artists, writers, theologians, and academics, amongst them several Nobel Prize winners – to declare their wholehearted support for Germany's war effort.[6] A translation of the manifesto, bearing the title "L'Appel aux «Nations civilisées»", was published in two of the Paris dailies, *Le Temps* and *Le Figaro*, on October 13th, and it will have been this that set Guitry to thinking about the possibility of a filmic counterblast.

Harding's unqualified statement makes it sound as though *Ceux de chez nous*'s subjects must all have been filmed after the manifesto's appearance in the French newspapers, and filmed with their knowledge that it was intended as a response. However, another out-of-print item – a card from *Les Fiches de Monsieur Cinéma: Histoire Illustrée du Cinéma Mondial* which is devoted to *Ceux de chez nous* – quotes something Guitry said in 1915 – most probably at the film's premiere – and this makes it clear that at least some of the filming had been done before he had seen Fulda's manifesto, and that it had been undertaken for wholly non-propagandistic reasons:

> These films were originally intended for my personal en-
> joyment, a select audience, and, later on, for teaching.[7]

It was only after "L'Appel aux «Nations civilisées»" appeared, and caused nationwide indignation, that Guitry saw how putting these separate sequences together and accompanying them with inspirational commentary might constitute a useful response:

30

But the German intellectuals' proclamation and the monstrous employments of their culture gave me the idea that there was perhaps an immediate and very great national interest in letting the publics of France and other nations know more about those who contribute magnificently to the brilliance of French genius.[8]

I should pause here to address a couple of minor worries which the second part of Harding's statement – the bit of it which reads "By way of patriotic reply he decided to make a film which would show some of France's greatest men in the arts" – might have prompted. If Guitry had decided to make a film featuring "France's greatest men in the arts", why does *Ceux de chez nous* include a sequence devoted to Sarah Bernhardt, France's leading actress? One possibility is that Guitry simply changed his mind and went from thinking that an all-male line-up would be less appealing than one featuring a woman, especially a woman as revered as Bernhardt. All 93 of the signatories to Fulda's manifesto had been men; how much better would the Frenchman's response be if it included a woman, and a woman of international renown, at that? The other possibility is that Harding was using the word "men" to mean "people", something that would raise an eyebrow today, but which in the 1960s would have gone largely unnoticed.

The other worry Harding's statement might have prompted stems from *Ceux de chez nous*'s inclusion of a sequence devoted to Henri-Robert. Henri-Robert was one of France's leading lawyers – at the time Guitry filmed him, he was President of the Paris Bar – and later on became a historian. But at no time could he have been regarded as an artist. Was this another instance of Guitry abandoning his original plan? This worry, unlike the last, *is* addressed by Harding: "The inclusion of Maître Robert [sic] … may cause surprise. Reflection will show that the art of the advocate differs little from that of the actor. In fact, the sequence depicting Maître Robert was the most elaborately stage-managed of the whole film … While the camera turned Maître Robert improvised one of his finest speeches and worked in effects which he never surpassed in the most dramatic of his cases."[9]

But let us set these minor matters aside, and return to the sequence featuring Degas. What does Harding tell us about that?

The elusive Degas refused to be filmed, so Sacha lurked outside his house on the boulevard de Clichy one morning and caught him emerging, stumpy and white-bearded, a coat and umbrella hanging from his arm as he looked suspiciously around before scurrying down the street.[10]

So this was why Degas was filmed when he was out and about, when everyone else was filmed in a domestic setting, most usually engaged in something viewers could regard as activity that was characteristic of them (e.g. Bernhardt reading lines of poetry, France at his writing desk, Monet working away at a painting, Rodin carving, Saint-Saëns playing the piano and conducting): Degas had turned down Guitry's invitation, but, undeterred, the 30 year old impresario had opted to get what he wanted by setting up a camera in the street and waiting for the unsuspecting artist to come his way.

Harding was a serious biographer,[11] and I was grateful for what he tells us about *Ceux de chez nous*, and for what he says about the Degas sequence being shot without its subject's consent, but I couldn't help being struck by just how careless is the rest of what he says about that sequence. To begin with, he states that Guitry filmed Degas emerging from his house on the boulevard de Clichy, but in the very first still (#1) what we see is Degas on the pavement, already walking towards us, not emerging from a building. When this discrepancy first struck me, I was inclined to dismiss it: in all likelihood, Degas had emerged from his house only seconds before Guitry had started filming, and Harding was guilty of nothing more serious than a minor abridgement. I shall come back to this shortly.

The next thing to strike me as odd was that, although, as Mc-Mullen puts it, "[Degas] had never been … a fine figure of a man," and his rolling gait had attracted amused comment from a number of his acquaintances,[12] it is misleading of Harding to say that the man we see walking towards us is "stumpy", i.e. has short fat legs. He appears to be of average height and build.

The third thing I couldn't help noticing was that Degas does not have a coat and an umbrella hanging from his arm, as Harding says;

he has a coat draped over his left arm and the umbrella is carried in his right hand.

Each of the three puzzles mentioned above look quite trivial, though their combination could lead an ungenerous reader to wonder whether Harding had actually seen the sequence or was instead relying on second-hand testimony. A fourth puzzle struck me as being more serious, however, and when added to the other three, left me wondering whether Harding mightn't have been looking at a different bit of film – an outtake, perhaps – for his claim that, after emerging from his house, Degas is seen to be "look[ing] suspiciously around before scurrying off down the street" has no basis in the nine-second sequence that I am dealing with. When the sequence opens, the artist is walking towards us, and his eyes, which are hidden behind the tinted glasses his failing sight obliged him to wear in his later years, are fixed on the way ahead. And when, two-thirds of the way through the sequence, the woman accompanying him appears to spot the camera and says something to the old man while gesturing in its direction, still we don't see Degas look suspiciously around him. He does lift his head, but only to look at his companion, not at the camera, and as he moves on past (#27–42) the expression on his face and his general demeanour are unchanged, and he continues to walk, not scurry.

By now, I was looking around for other sources of information, sources I hoped would prove to be more comprehensive, and more reliable too. Where had Harding got his information from, I wondered. Might what he was offering us be an edited version of something he had found more fully documented elsewhere – in Alex Madis's 1950 biography, *Sacha*, perhaps?[13] I duly ordered a copy, only to discover that it contained less than a page about *Ceux de chez nous*, and made no mention at all of the Degas sequence. So maybe Harding was basing what he said on the testimony of one or more of the other people he'd interviewed for the book – lifelong friends of Guitry's such as Jean Cocteau and René Fauchois, for instance? Since Cocteau and Fauchois both died in the early 1960s, and none of the other people Harding acknowledges is still with us, I wondered what else I could do.

The answer to this question took me longer to find than it should have, probably because I was relying too heavily on the foolish assumption that anything worth knowing about Degas and Guitry would be available in

English, even if it originated in French. I had gone through a fair number of books in English, drawing a blank in each instance, before it occurred to me that I should order Henri Loyrette's *Degas,* a biography which was published six years after McMullen's, in 1991, and which is still unavailable in English some thirty years later. In Chapter IX of Loyrette's splendid book, I found exactly what I'd been looking for – an account, in Guitry's own words, of how he had come to acquire the footage of Degas:

> And here is the exact story of the visit I paid him. The day I filmed Renoir, I told him of my intention to film Degas as well. Renoir asked me if I knew him. I told him I didn't have that pleasure. So Renoir told me, "Oh, I don't advise you to go because he will not receive you."
>
> "Why?"
>
> "Because, for six years, he did not want to receive anyone. If you want to go anyway, do! But you will see …"
>
> Well, I saw. Renoir was right.
>
> I went to the boulevard de Clichy and I climbed the five floors that separated M. Degas from the rest of the world. If you happen to visit the boulevard de Clichy, please admire number 6, the too modest house that contained this great man …
>
> I rang … An old girl opened to me. She was wearing dark glasses … She looked very uncomfortable. And addressing me, who had never been to M. Degas's, she asked, "What do you want?"
>
> I said, "I would like to see M. Degas."
>
> "He's waiting for you?"
>
> "No."

"So, don't bother, you will not see him!"

"Give him my card ..."

"No need, sir, he does not want to see anyone."

I was about to leave when a door opened and I saw M. Degas appear, who, with his hat on his head, his coat on his arm, was about to go out.

Over eighty years ... White beard ... Terrible lips ...

He asked, "What is it?"

The maid said to him, "It's a gentleman, who would like to see you."

So I went up to him and handed him my card because I knew he was hard of hearing and I didn't want to repeat my name.

He looked at my card, and my name, which I relied on, did not make any impression on him. He had certainly never seen or heard it. He said to me, "What do you want?"

I pointed out to him that the five flights I had just climbed had left me out of breath. Then, offering me a little chair in the hallway, he said, "If you're out of breath, sit down for a moment."

I shall not dwell on the difficulty of asking something of a man who receives you in this way ... Nevertheless, I explained to him the purpose of my visit. I told him that there would be great interest in him along with all the great men of our time.

As soon as he understood what I wanted, he cut me off:

"No!"

"Oh! You do not want to? Just for five minutes ..."

"No, sir, no!"

"But yet ... M. Degas ..."

"Do not insist! Do not insist! Me, I want to stay in my corner ... I ask nothing of anyone!"

"You will be with Rodin, Claude Monet, Renoir ..."

"I do not care!"

His niece, who was going out with him, told me that there was nothing to do. She said, "No, no, no, do not insist, no, he does not want anything, it's the same with the Légion d'Honneur ..."

So, to see how he would react, I insisted, "My dear Master ..." At that word 'Master', he stood up in front of me and told me in a tone that I would never forget: "'Master', why 'Master'? Speak to me as a man like any other, please!"

Before leaving, I watched him steadily and attentively. I had the impression I would never see him again, ever ... Moreover, I did not see him again.

I cannot tell you how impressive this man's face was for its beauty, nobility, contained rage and melancholy ...

He was almost blind. He kept his eyebrows high and the fixity of his eyes was unforgettable.

I took leave of M. Degas, telling him how pleased I had been to see him, and expressed my great admiration for

him. He made a sort of grimace, which must have been his most gracious smile.

I bowed to him. He raised his hat ... And I went out ...

I have never been so badly received but I have never been so sure that it was painful for a country like ours that such men are so old.

...

I went as fast as I could down the five floors I had climbed. And I found, downstairs, in the street, the two cameramen I had brought. I said to them then, "Listen, in a moment, a man of eighty will come out of this house. He must be filmed without his being aware of it." For, above all, I did not want to disoblige M. Degas, nor to annoy him.

Unfortunately, about forty onlookers surrounded the camera. I thought that M. Degas, seeing them, would not come out of his house. So I sent the cameramen to stand at the corner of the first street on the right.

M. Degas, on leaving, went left ... And for half an hour, there was an untold race along the boulevard de Clichy ...

Finally, a little above the Moulin Rouge, the cameramen, cleverly hidden behind a kiosk, could film him for twenty meters ...[14]

A footnote to this lengthy quotation explains that it is drawn from *Sacha Guitry: Le petit carnet rouge et autres souvenirs inédits*, a volume which, as its subtitle makes clear, gathers together some of Guitry's unpublished writings, and which, although it was published as long ago as 1979, also remains unavailable in English. I ordered a copy, and found that a whole chapter of the book is given over to *Ceux de chez nous*, its opening section explaining how the film came to be made, and subsequent sections saying

something about each of its *dramatis personae*.[15] It made for fascinating reading, but the key points – those relating to the encounter with Degas, I mean – were all to be found in the passage Loyrette had seen fit to excerpt, so that further quotation is unnecessary.

Harding's biography of Guitry was published some years before *Le petit carnet rouge*, but he was almost certainly depending on what Guitry had written about *Ceux de chez nous* for what he himself says, because the overlap is extensive, and if he had had another source, I haven't been able to discover what it was. Notwithstanding this, there is a puzzle, because according to Harding, as we saw earlier on, "Sacha lurked outside his house on the boulevard de Clichy one morning and caught him emerging, stumpy and white-bearded, a coat and umbrella hanging from his arm as he looked suspiciously around before scurrying down the street," while according to Guitry, as we saw just now, he was unable to film Degas as he came out of No. 6, and instead had to race along the boulevard de Clichy for a full half-hour before he and his crew were able to get into a position to take the footage they wanted. How to explain the discrepancy?

3

Shouldn't we simply disregard what Harding says about where the footage was taken? Why doubt the word of someone who was there, or suppose that it needs to be weighed in the balance with the word of someone who wasn't, especially when the latter has already demonstrated how careless with the facts he can be? If I had a worry about this, it was chiefly because Guitry's account was penned in 1939, a quarter of a century after the events it describes. A quarter of a century is a long time – long enough for Guitry's memory to have played tricks on him. Isn't it possible that Harding wasn't offering us a careless version of the account given in Guitry's unpublished papers but had discovered something wrong with it, and had offered us a silently corrected account of his own? None of this seemed likely, but I wanted to be sure, or as sure as I could be.

I wasn't only worried about the possibility that Guitry's memory might have played him false. There is something about his account that, at least on the face of it, doesn't add up. He tells us that after Degas and his companion emerged from No. 6 and turned left rather than right, he and his

crew had to pursue them up the boulevard de Clichy for a full half-hour, only being rewarded with the opportunity to film them "a little above the Moulin Rouge". Now, Guitry must have meant that the couple went left *as seen from the street*, not left *as seen from the house*, because an extended race going east along the boulevard wouldn't have been possible, given that it terminates at the rue des Martyrs, a mere 50 meters away. Moreover, if their pursuit of the old man only concluded a little way above the Moulin Rouge, then, unless he and his companion went east to begin with and then doubled-back, it is difficult to see how this might have been possible, for the Moulin Rouge is only a little over 500 meters from No. 6, at No. 82, and even if the couple had been walking very slowly, it wouldn't have taken them more than ten minutes to reach it. Indeed, they could easily have gone two or even three times that distance in under thirty minutes. One way of trying to account for this would be to suppose that the couple stopped off somewhere, perhaps at a café, so that their progress up the boulevard wasn't continuous. If we took this possibility seriously, we'd have an explanation of how Guitry and his crew were able to overtake the couple without being seen, set up their camera behind the kiosk, and then lay in wait for them once they resumed their walk. All of that sounds pretty persuasive, until one remembers that Degas and his companion have the buildings on their left and the road on their right, when, if the story I've just told had been correct, the buildings would have to have been on their right and the road on their left.[16]

The problem I've just identified isn't insurmountable, however, not if we use our imagination. After all, isn't it possible that Guitry and his crew did pursue Degas and his companion to a point just beyond the Moulin Rouge, but then decided to stop, calculating that the couple would at some point want to retrace their steps, so that all the team had to do was set up their camera and wait? In that case, we'd have a perfectly acceptable explanation of why it was only after half an hour on the boulevard that Guitry and his crew were rewarded with their bit of footage, and we'd no longer have to worry about why the buildings we see are on the couple's left and the road on their right, for that is just where they'd have to be. All I've shown so far is that Guitry's account is a coherent one. Whether it is accurate is another matter.

Let us now ask ourselves whether Harding's account is similarly co-

herent. Unlike Guitry, he doesn't tell us which way Degas and his companion turned on leaving No. 6, but because he says that the filming started at that point, and, as we've already been reminded, the buildings are on their left and the road on their right, it follows that they must be heading east, towards the rue des Martyrs. I have already pointed out that the boulevard de Clichy terminates at that junction, and this means that, even if they were walking quite quickly, the couple wouldn't have covered the 50 meters in less than half a minute. That is plenty of time for Guitry and his crew to secure their nine seconds of footage. Since I can find no other grounds for doubting it, I conclude that Harding's account, like Guitry's, is at least a coherent one.

But how to adjudicate between them, for only one of them can be true? Is there anything else we can appeal to in order to settle the matter?

One thing it would be easy to miss as we watch the sequence – concentrating as we probably are on the people we see – is the faint presence, there in the background (and circled in the still shown below) of a tall building which appears to jut out from the right at an oblique angle to the boulevard.

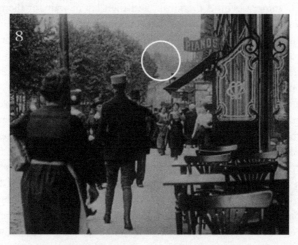

So, the question we need to ask ourselves is this: from which of the two locations we are being asked to consider would such a structure have been visible?

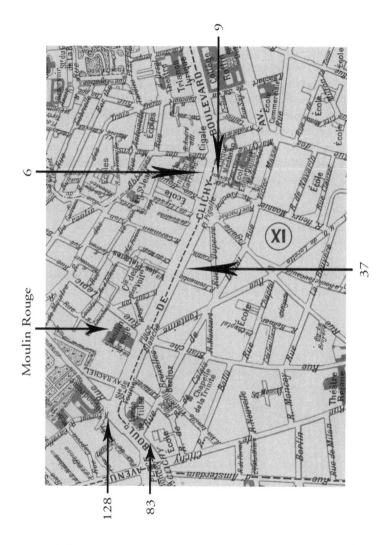

Detail of a street map showing the boulevard de Clichy and its environs as they will have looked in 1915. From Fernand Bournon's *Paris-Atlas Illustré* (Paris: Librairie Larousse, 1900). The numbers are those of the buildings referred to in this essay.

Had the film been taken where Harding says it was, nothing of this kind would in fact have been visible. All one could have seen, had the trees permitted it, were the multi-storied apartment blocks beyond the Place Pigalle, some 250 meters away, which had been put up on the southern side of the boulevard in 1879. I say this because the boulevard curves away to the right after 125 meters, and beyond that nothing juts out from the right, all of the buildings on its northern side being hidden from view. Harding's account can at last be set on one side, therefore: the filming was not done along the stretch outside No. 6.

But would the structure we see in the background have been visible from where Guitry says the film was taken, a little above the Moulin Rouge? Frustratingly enough, the answer to this is that it would not have been. The building which can be seen from there is No. 128 boulevard de Clichy, but this lies on the far side of the traffic circle after which the boulevard de Clichy swings round to the south-west, and as well as not jutting out from the right, its profile is utterly different from the structure we can see (admittedly only faintly) in the background to Guitry's film. Here it is, seen from the north-eastern corner of the boulevard de Clichy, some 180 metres beyond the Moulin Rouge:

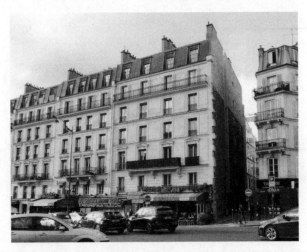

My first thought, on seeing No. 128, was that it must have been built after 1915, replacing the buildings we see in the film, but no: No. 128

has been there since 1884, as an inscription incised into its walls makes clear.

The inescapable conclusion is that it's not just Harding who wrongly identified the location, but Guitry too.

But if not outside No. 6 or a little above the Moulin Rouge, where might the film have been taken? I think the clue is to be found in something else whose significance we might easily overlook. This is the sign we can see overhanging the pavement, and which we only lose sight of in the last few frames, when the camera is panning away to the left. Made in the Art Nouveau style which had flourished in Paris between 1890 and 1910, the sign tells us that this stretch of the boulevard is home to a piano showroom. If we could only discover the showroom's location, our quest would be at an end.

It would have been easier if there had only been one piano showroom on the boulevard de Clichy during this period, but it transpired that there were two, both of them owned by the Georges Focké company. One was at No. 37, and the other was at No. 83, meaning that both were on the other side of the boulevard from the one I'd been considering, the first about 300 meters from No. 6, the second some 600 meters beyond that, on the western side of the boulevard after it swings round the traffic circle and runs south-west.[17] Now I had a bit of luck, discovering on the Internet an old postcard showing the frontage at No. 37, as it looked in 1900:

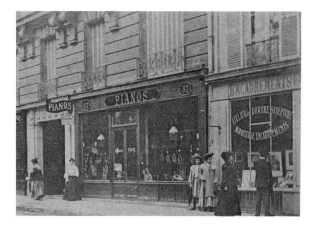

The sign overhanging the pavement in this photograph is indistinguishable from the one overhanging the pavement in Guitry's film. I need hardly say how gratifying this was, but of course it didn't allow me to conclude that the filming had been done outside No. 37, because an identical sign could have been hanging outside No. 83, both showrooms belonging to the same company. Nevertheless, this was a big step forward, for all I had to do now was work out what we would have seen in the background had the filming been done in either of these locations, while keeping my fingers crossed that one and only one of them would show a building or group of buildings like the one whose presence had allowed me to rule out Harding's and Guitry's own accounts.

Let us begin by considering what we would have seen had Guitry and his associates been standing near No. 83. Would there have been a building or group of buildings obtruding from the right, and standing at an appropriate angle to it? The answer is that there would have been. This was the Lycée Jules-Ferry, which had been founded in 1913, just two years before the filming was carried out, parts of which stand at the corners of the boulevard de Clichy and the rue de Douai. Here is a roughly contemporary photo, taken from the other side of the boulevard, probably outside No. 134:

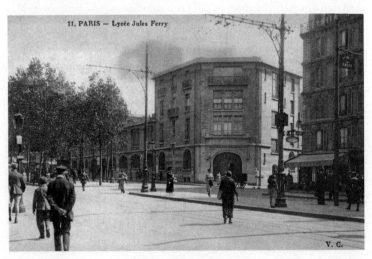

11, PARIS — Lycée Jules Ferry

V. C.

But does this building bear any resemblance to the one we see in the film? Of course, and as I've already admitted, the building or group of buildings we see in the film can only be seen indistinctly; still, its lines and those of the Lycée as it stretches back up the boulevard are altogether different. It isn't high enough, for one thing, nor does it have anything like the profile we can just about discern in the film. As a result, we must give up on the idea that the filming was done near to the piano showroom at No. 83.

So now let us ask what we would we have seen had Guitry and his associates been standing near the showroom at No. 37, and looking back towards the Place Pigalle. After the Place, the boulevard curves away to the left, and I was able to find another postcard showing the buildings we would have seen at around this time – the nearest of them on the corner of the boulevard and the Place, and those beyond them lining the boulevard itself:

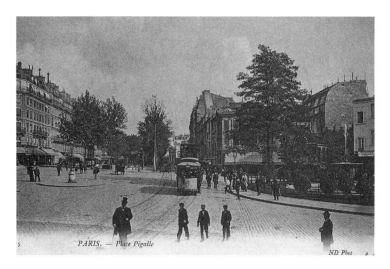

PARIS. — Place Pigalle

ND Phot

A comparison of the buildings we see in this photograph with the ones we see in Guitry's film was enough to persuade me: the footage taken by Guitry and his associates was obtained near No. 37. The buildings on the corner of the Place Pigalle and just beyond it on the boulevard were demolished a long time ago, and in their place stand a number of ugly

contemporary structures. But the tall building with the curb roof and distinctively canted chimney stack was put up in 1882, and it stands there to this day, at No. 9 boulevard de Clichy. Straddling the passage Alfred Stevens, it is almost directly opposite Degas's home at No. 6. Here is what it looks like today:

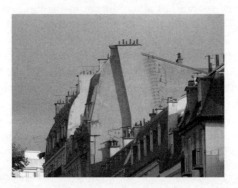

I hope I have said enough to convince readers that the filming was done not where Guitry says it was, a little above the Moulin Rouge, but from where I say it was, a little above No. 37. However, if Guitry's account has been shown to be wrong, the story of how he and his associates pursued Degas along the boulevard and set up their camera a little above the Moulin Rouge at least offered us a plausible explanation of how they settled on their location, while my own account leaves that choice wholly mysterious. Why would they have chosen to set up their camera a little above No. 37? It surely couldn't have been selected on the merest off-chance that Degas would take that route rather than the many others that were open to him? I shall return to this question in the next section.

4

It is pure guesswork, but what might Degas and his companion be doing, heading west along the boulevard while Guitry and his associates lie in wait for them? It should be said straight away that Degas spends a lot of his time in his apartment at No. 6, and that, now he can no longer

work, and reading and writing are also impossible, the urge to escape its confines, even if it's only for a daily *promenade*, with stopovers at one or more of the arrondissement's cafés, must be quite great.

So where might he and his companion be headed on this particular day? One possibility is that they are making for the café outside which Guitry and his crew have set up their camera, and that it is only the men's presence that prevents them from taking seats at one of the tables we can see. Another possibility is that they are on their way to one of the artist's favourite places, the Café Victor, in the boulevard des Batignolles. This is a good thirty-minute walk away, but the aging Degas is still just about up to outings of that kind.

It is equally possible that Degas and his companion are coming away from somewhere rather than making for it. The artist is known to have been a habitué of the Café de la Nouvelle Athènes,[18] for example,

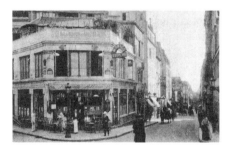

and of Le Rat Mort, both of which are popular watering holes for artists, writers, and composers, and both of which are situated in the Place Pigalle.

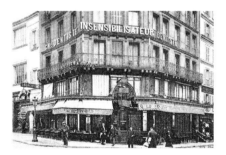

My hunch is that Degas had a routine, and that proceeding west along the southern side of the boulevard de Clichy, either after refreshments in the Place Pigalle or else en route to them here or in the boulevard des Batignolles, will have been something he did on a regular basis. If Guitry had done his homework, he would have known this, so that stationing himself and his crew near No. 37 wasn't something he did on the off-chance that Degas would happen to come that way, but with a measure of confidence that that is what he would do.[19]

I must admit to not being comfortable about the gulf between Guitry's account and my own. Yes, a quarter of a century did separate the event from his recollection of it, and if he'd misremembered things, that wouldn't be so very surprising (perhaps especially because he's a dramatist, and one who might well have dined out on this story many times in the intervening years). But still, although I am quite certain that the film was taken where I say it was, and not a little way above the Moulin Rouge, I don't think this commits me to saying that there couldn't have been a race along the boulevard of the kind Guitry describes. If it did indeed last half an hour, and there were no stops, Degas's route would have to have been an odd one – taking him up the boulevard, back down it, and then up it again, this time on the southern side – but who am I to say that this wasn't the way the artist regularly went, and that, knowing as much, Guitry and his two associates, despairing of catching the artist along the first and second legs of his promenade, managed to catch him on the third?

5

I turn now to another question – that of when the footage was taken. Guitry neglects to tell us, and those who've had anything to say about it have expressed divergent opinions. Daniel Halévy included a still from the sequence in his 1960 memoir *Degas Parle …[My Friend Degas]*, and captioned it "Degas about 1910"; McMullen used a slightly cropped version of the same still in *Degas: His Life, Times, and Work*, and captioned it "Degas in the boulevard de Clichy, 1914"; Robert Gordon and Andrew Forge included the same still, uncropped, in their *Degas*, and captioned it "Degas walking along the boulevard de Clichy, from the film *Ceux de Chez Nous* by Sacha Guitry, c. 1914"; Jean Sutherland

Boggs opted for a different still from the same sequence in her *Degas,* and captioned it "Degas in the streets of Paris, 1912–1914"; and Henri Loyrette, when telling us about what led up to the filming in his *Degas,* states that it was carried out in 1915.[20]

We can reject Halévy's dating pretty much out of hand, as we can his assertion that when he visited Degas in 1916, the artist was living on the boulevard des Batignolles. Degas never lived on the boulevard des Batignolles, although, as we have seen, he did spend time there, as a regular in the Café Victor, and as a guest at No. 34, when his friend Edouard Manet lived there. Halévy was 88 years old when *My Friend Degas* was first published, and we must suppose that his memory did occasionally lead him astray.

When I first stopped to consider the question of when Guitry had filmed Degas, I saw no reason to doubt that it was done in 1914, just as McMullen, for one, claimed. And my guess was that it had been shot in the spring or early summer of that year, since the trees are in leaf, a café has set up tables and chairs on the pavement, and although Degas has an overcoat draped over his arm, and he and his companion carry furled umbrellas, everyone is dressed in ways that suggest there is warmth in the air. The alternative to thinking that the footage was filmed in the spring or early summer of 1914 is to suppose that it was taken in the spring or early summer of 1915, but could that possibly be right? By that time, after all, the city was enduring bombing raids by the small aircraft known as *Taubes,* and by Zeppelins too; it was filling up with soldiers, many of whom were injured or suffering from "shell-shock"; additionally, there was "scarcely a street without its hospital, its work-room, its depot of necessities for the combatants or their families".[21] It is also to suppose that, not even a day's drive away, men were fighting and dying in vast numbers – amongst them, quite possibly, men known to the people we see coming and going here on the boulevard de Clichy.[22] Doesn't the relaxed demeanour of the people we see in this bit of *Ceux de chez nous* pretty much rule out its having been shot in the spring or early summer of 1915, with the war in full swing? Mustn't we suppose that it was shot the previous year, at a time when people could still go about their lives imagining that war would be avoided?

As I read around, trying to find out more about Paris during this period, I started to have my doubts.

Within days of the war being declared, the city's streets were largely deserted, its theatres and cinemas were closed, and its cafés, restaurants, and shops shut early or didn't open at all.[23] And as the historian Mary McAuliffe has pointed out, it wasn't just the city that was transfigured, it was also the populace: "the whole city appeared to be in mourning," she writes, "[with] everyone [wearing] black or the darkest blue ..."[24] By the spring of 1915, however, things had changed, and quite significantly. The Germans' original offensive, which had brought them to within 30 kilometres of the city's eastern outskirts, had been repulsed, the French army and the British Expeditionary Force having counter-attacked along the Marne River and forced a 60 kilometre retreat.[25] Helen Pearl Adam, an English journalist who was based in Paris throughout the war, described what happened as a result. "Paris began to wake up a little," she wrote, quickly adding a cautionary note: "Like anybody else suddenly roused, [she] did not show herself in her best mood." Exactly what she meant by this is made clear in the very next sentence, when she quotes the eminent historian Frédéric Masson – himself a Parisian – as crying out for greater decorum: "Give us back our grave, serious, magnificent, silent Paris of the autumn."[26] T. S. Eliot wrote that "human kind / cannot bear very much reality,"[27] and seeing just how quickly the French capital had cast off its grave, serious, magnificent, silent self, Pearl Adam and Masson would surely have been tempted to agree.[28]

But there were other things which, once I noticed them, left me wondering whether the Degas sequence mightn't have been filmed in 1915 after all. The first of these is the total absence from the boulevard of any other vehicle than the *triporteur*. Before the outbreak of war, Paris's streets had been thronged with horse-drawn carriages – broughams, landaus, hansoms, and the like – and they'd been thronged with motor-vehicles, too – cars, motorcycles, buses, trucks, and so on – but after the war got under way the vast majority of these vehicles had been requisitioned by the army, and were being used to transport men and materiel to the front. By the spring of 1915, the capital's roads were empty of almost everything except pedestrians and cyclists, though old delivery vans would sometimes be put to use in place of the missing buses. Of course, it might be argued that the absence of anything except pedal-powered vehicles from a film sequence that lasts only nine seconds is not so very surprising, but even if I accepted that – and I don't,

because this is clearly a busy time of the day on one of the city's busiest thoroughfares – it is surely telling that people are walking not just on the pavements but in the road too, and that they are doing so in a manifestly unhurried way. To this should be added the behaviour of the man on the *triporteur*, who spends most of the time he is in view (#13–28) looking back over his shoulder, unconcerned, so far as we can tell, about the presence of any other vehicles, or the possibility of a collision.

The other thing that made me hesitate over the dating of Guitry's footage is the profile of the people we see. Though it is not so immediately striking as the absence of normal road transport, it is a nevertheless arresting fact that there are twice as many women as there are men to be seen in this section of *Ceux de chez nous*. Again, it could be argued that this is merest happenstance, and that, if Guitry had kept filming, the disproportion would have disappeared. Another possibility suggests itself, however. Consider what Emmanuelle Cronier tells us about the capital's populace in the months following the outbreak of war: "As husbands, sons, and fathers left for the front ... women appeared in the streets ... in larger numbers than ever before, both proportionately but also in absolute terms."[29] Cronier refers to this as "the feminization of the streets",[30] a phenomenon witnessed not just in Paris but in London and Berlin too.

As well as the disproportionate number of women, we should note that only one of the half-dozen men we see is unquestionably of an age that makes him liable for military service, and that is the man whose uniform tells us that he is already in the army (#1–17).[31]

So, although I cannot be absolutely sure, if I had to put money on it, I would say that Loyrette's 1915 dating of the sequence is the correct one.

6

Consider once again the very first still (#1), this time focussing not on Degas and his companion but on the man in uniform who is walking away from us. Guitry's activities have clearly piqued his curiosity, and he continues to look at the camera even after he has walked on past. His kepi, tunic, breeches and boots tell us that he is

an infantryman – in the slang parlance of the day, a *poilu*.[32] We catch a fleeting glimpse of a chevron on his right forearm (#2) and this tells us that he is *un soldat 1ᵉ classe*, but we have no way of knowing whether he is an enlisted man or a conscript. If I am right about this being 1915, we can say with reasonable certainty that he will have been one of the 2.9 million who were mobilized immediately after war was declared. What is he doing here in Paris, though? Why isn't he out at the front? Perhaps he is one of the lucky few who have been assigned duties in the capital. Or perhaps he is one of the still small number of soldiers who have been allowed to go on leave – *permissionaires*, as they were known. He has something tucked under his left arm – a copy of *Le Matin*, perhaps, which in 1914 had declared itself to be "the best informed newspaper in the world". More interesting than any of these questions is the equally unanswerable one of whether he survived the war or wound up being one of the 1,400,000 to perish.

Shortly after the *poilu* goes past, two women appear in quick succession, both going in the same direction. The first looks to be slightly ahead of the soldier (#4) and the second somewhat farther behind (#6). Both women wear ankle-length dresses, the first's pale in colour, the second's dark; the first has a strange looking hat on her head – unless I'm mistaken, it is a three-cornered affair with pompoms at each corner – while the second is bare-headed. We get to see very little of the first woman because she is quickly obscured, initially by the second woman, and then, after a brief interval, by the approaching Degas. However, one thing becomes clear just before the second woman comes between us, and that is that the first is accompanying the *poilu*. They must have parted as they approached the lamppost, she skirting it the left and he to the right, but once on its far side they fall into step alongside each other, and remain that way as they pass Degas and his companion, and as they disappear behind the other pedestrians who are coming our way. Apart from the fact that she is accompanying the soldier and is dressed in the way I have described, we can say nothing else about the first of these two women. Is she his wife? fiancée? girlfriend? sister? We will never know.

Is there anything more to be said about the second woman? For one thing, what we might initially have supposed was a belt around her waist turns out to be an apron's strings. And like the *poilu*, she carries some-

thing under her left arm, in this case a parcel evidently wrapped in paper and possibly done up with string. She would seem to be in something of a hurry, because she cannot have failed to notice the camera yet doesn't spare it a backward glance, just keeps going. What could she be doing? Is she *une femme de chambre,* sent out by *Monsieur* or *Madame* to collect something from the nearby post office? Perhaps she is *une marraine de guerre* – that is, one of the women who agreed to accommodate *permissionaires* who had nowhere to stay in the capital – bringing her lodger some freshly laundered clothes? As Degas approaches, she turns her head in his direction. Maybe she has after all been wondering what the film-makers are up to, and it occurs to her now that the imposing figure bearing down on her might be what they are waiting for. But of course, she might only be keeping an eye on the old man in tinted glasses so as to be sure he doesn't bump into her. Those are two possibilities; a third is that she is not looking at Degas at all, just curious to know what it is that's causing the flat-capped man pedalling by on his *triporteur* to stare back in their direction, rubber-necking all the way. In any case, she lowers the parcel she has been carrying under her arm and suspends it by the string we can now say for sure the parcel is tied up with.

There are a number of other people I should mention before I come back to the man on the *triporteur.* The first is the young man we see crossing from the central reservation to our side of the boulevard (#9–13) and just avoiding the *triporteur* as it passes behind him. He too is wearing a flat cap, but his suit, and the tie we will be able to see when he's drawn somewhat closer, suggest that he could be an office worker of some sort – a bank clerk, perhaps. In the penultimate still (#41), at which point he is coming up behind Degas and his companion, we catch sight of something in his left hand which has hitherto been invisible – quite possibly another newspaper – maybe a copy of the illustrated weekly *Le Petit Parisien.* He appears to be in his late teens; if he were any older than that, he too would have been in uniform. Unless he's unfit, he will be very soon, of course.[33]

We have no sooner spotted the suited man crossing the road than somebody else (#12) sweeps into view. It's another woman – this one walking away from us, but, unlike the other people going in that direction, she is in the road rather than on the pavement, having been deterred, most probably, by the number of people she can see coming the

other way. She is wearing a pale ankle-length dress, has a small hat on her head, and might or might not be wearing elbow-length gloves. What it is she holds in her right hand is hard to make out, but it's light enough to be a clutch purse or a slender handbag.

The other people I want to say something about are the ones we first see ahead of the *poilu*. Almost entirely obscured by the café's glazed partition when we first see her (#1) is another woman walking away from us. She wears a dark, ankle-length dress, but it's hard to say whether she has a hat on or is bare-headed because she is too far away, and she no sooner comes into view than she disappears again, this time behind the women who are ahead of the *poilu*, and who've been coming our way from the start.

We see only two of these women at first (#2) but then a third (#6) and eventually a fourth (#23) also come into view. The first two – a bareheaded blonde wearing a white shirt and dark, ankle-length skirt, and with a handbag tucked under her left arm, and, slightly behind her, a bareheaded brunette clad in a dark, ankle-length dress with a pale bodice, and also carrying something tucked under her left arm – seem to be involved in an exchange of some sort. After a while, the brunette appears to hold something to her mouth – a snack, perhaps. Just as the *poilu* draws level with them, the blonde turns towards the brunette and raises her right arm. Could she be chaffing her for the unseemliness of eating in the street? Or is she pointing to the man on the *triporteur*, whose rubber-necking might easily have attracted her attention? The brunette does lower the hand she has had to her mouth, but I can't helping thinking it more significant that she also turns her head in the direction of the *triporteur* and then leans forward, as though to avoid losing sight of it as the two women coming up from behind step out to their right and threaten to obscure her view.

The second pair are seen only fleetingly, just long enough for us to say that, like the first pair, they are bareheaded, and their attire once more nothing unusual – one being clad in a pale, ankle-length dress, and the other wearing a pale shirt and a dark, ankle-length skirt.

If at first we thought the four women were together, we might subsequently reconsider, for as the two in front continue walking towards us, the two behind move away to their right, eventually stepping into the road, with neither couple appearing to say anything to the other. How-

ever, it is equally possible that they have been together, and that no words are necessary because they will be reunited a little further on, at a point where the pavement is less crowded. What could they be, I wonder? Entertainers of some sort? Dancers, perhaps, on their way to rehearsals at the Moulin Rouge, which, as we've already noted, is only a five-minute walk away, on the other side of the boulevard? As a matter of fact, if I'm right about this being the spring or early summer of 1915, we can rule that out, because the Moulin Rouge, which had opened in 1889, had been gutted by fire only weeks before this bit of film was shot, on February 27th, 1915. Another possibility – a much less appealing one, but one which cannot be ruled out – is that they are four of the six thousand *putains* registered with the préfecture de police, and are returning from a morning's trade near the Eglise Saint-Vincent de Paul or the Hôpital Lariboisière, areas which, being close to the Gare du Nord and the Gare de l'Est, and parts of what came to be called "Leave Land", would in due course witness what one historian called "an explosion in open-air sex".[34]

It is worth pausing here to observe that although most of the figures we see in Guitry's film are wearing dark-coloured clothing, it is clearly not *de rigueur*, as it had been during the months immediately following the outbreak of war.

Let me return to the man on the *triporteur*. He presents us with something of a puzzle, since he doesn't look young enough to have escaped conscription, and doesn't look old enough either. If some of the people in Guitry's film are indeed staring at him, it might not be because of his rubber-necking but because they too are wondering why he's in civvies rather than out there at the front, defending *la patrie*. Perhaps he has a disability. He doesn't look unfit, but the sort of condition that can exempt a man from military service needn't be obvious to an onlooker, of course. A second possibility is that he is the father of six or more dependent children, the Minister for War, Alexandre Millerand, having announced in April that men with that level of familial responsibility should not be required to serve. Men like him – that is, men of eligible age but not in uniform – regularly had to cope with accusations of cowardice, idling, and shirking – accusations made not just by resentful *permissionaires* but by the general public.[35] But what else can we say about our delivery man? Unless he is simply open-mouthed, he appears to be sporting a moustache. As well as his flat cap, he is wearing a pale jacket, dark trousers and

55

leather boots. He might also be carrying a bag over his shoulder, since I think we catch a glimpse of a strap running across his back. If we cannot tell what it is he is delivering – it could be anything from cabbages to copies of the satirical weekly *À la Baïonnette,*[36] from bottles of wine to posters featuring Millerand's watchwords, "Taisez-vous, méfiez-vous, des oreilles ennemies vous écoutent"[37] – we can at least hazard a guess at the manufacturer of his vehicle, since it closely resembles the type advertised by Les Frères Blotto, its front mudguards unlike any others I have been able to track down:

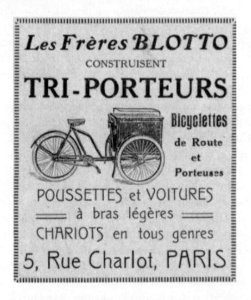

Unlike the *poilu* who turned to look back at the camera crew, and then, so as to avoid bumping into anything, turned back again, the delivery man, having swivelled round on his saddle, remains like that, captivated, apparently unworried about the possibility of an accident, until he disappears from view. It is quite clear that Guitry's activity has excited this fellow's interest, for although he probably has a delivery to make, and might even be overdue, his progress relative to that of the pedestrians going the same way shows that he has slowed to less than walking speed.

There is someone else whose presence could have been noticed as early as the very first still had we not been drawn to everything else that has been going on in the foreground and middle distance. This is a woman walking eastward on the boulevard's central reservation. She is garbed in yet another dark, ankle-length dress, carries a bag in her right hand, and supports a small child dressed in white on her left hip. Where might they be headed? Could they be on their way home from the Gare du Nord or the Gare de l'Est, having waved goodbye to the child's father as he boarded a troop train taking him off to the front? The stations are close by – no more than a twenty-minute walk away, in fact – but it's fair to say that the stations and their environs weren't safe places for unaccompanied women, and her husband would almost certainly have wanted to say goodbye at the door to their apartment, not on a station concourse heaving with men and equipment. A more plausible suggestion is that the pair are returning from an hour spent in the Square d'Anvers, a small park that is popular with mothers and their young children. The square is a mere ten minutes' walk from here.

It is time to return to Degas and his companion, who by now have drawn a lot closer, and are about to do what the *poilu* and his companion did, and skirt the lamppost, Degas going to his left, his companion going to her right. When I first saw this footage, I had no idea who the companion was. Guitry makes no mention of her while introducing the sequence, and her appearance goes unmentioned by McMullen, Harding, Madis, Halévy, Boggs, and Gordon and Forge. Who might she have been, I wondered. Later on, after looking at Loyrette's *Degas*, and after that, Guitry's *Le petit carnet rouge*, I would have my suspicions confirmed, but knowing nothing of those books at the time, I had to engage in yet more detective work.

One woman I was able to rule out straightaway was Degas's housekeeper Zoé, who had been working for him since 1882. Degas photographed the two of them together – he seated and looking away to his right, she standing behind him and staring directly at the camera – in the autumn of 1895, and we can see that she is already in her fifties or sixties, a grey-haired and substantial figure, quite unlike Degas's companion, who, filmed twenty years later, looks like she could still be in her late thirties or early forties.

38

I was able to rule out almost as quickly two other acquaintances of Degas's – the painters Suzanne Valadon and Mary Cassatt. Valadon had helped him to find his apartment in the boulevard de Clichy, but by this time she was 49 years old. And Cassatt, who was also doing what she could to help Degas in his last few years, was by now all of 71. Not that additional evidence was necessary, but photographs and paintings of both women show that neither of them bore any physical resemblance to Degas's companion.

Another candidate was Hortense Fourchy, the daughter of Degas's old school-friend, Paul Valpinçon. She had modelled for him, both as a child and as a grown woman, and she remained on good terms with him till the end of his life. But it turned out that she was born in 1862, so was even older than Valadon. We also have a photograph and an adult portrait to go by, but Fourchy and the companion likewise bear no resemblance to each other.[39]

Yet another possibility occurred to me after I acquired a copy of Paul Valéry's *Degas Dance Drawing*. Valéry first met Degas in 1893, and was a regular guest at the artist's apartment at 37 rue Victor Massé, in the years between then and 1912, when Degas moved to the boulevard de Clichy and started to lead a much more reclusive life. After describing the dreary dinners "old Zoé" used to prepare

for the two men, Valéry lets slip that the housekeeper had an assistant – a "young girl" called Argentine.[40] I couldn't be sure what Valéry meant by "young", of course, but if Argentine was somewhere between 10 and 15 years old in the mid '90s, that would have made her between 30 and 35 years old in 1915, and, therefore, not somebody I could easily rule out.

At a certain point, however, I remembered something McMullen makes brief mention of on the antepenultimate page of his biography: "At Nice, Cassatt found Jeanne Fevre, [Degas's sister] Marguerite's unmarried daughter, working in a hospital and persuaded her to go up to Paris to look after her uncle, and he accepted the arrangement with unexpected docility."[41] McMullen says nothing more about this arrangement, and when I first read about it must have assumed that Fevre was only called in to help quite late in the day, perhaps in the last few months or weeks of Degas's life. All I knew about Fevre was what McMullen had told readers earlier on in his biography, which was that she had published a 1949 memoir entitled *Mon Oncle Degas*, a book he found "occasionally unreliable",[42] and drew on only very sparingly. Put off by McMullen's lowly estimate of the book, I hadn't bothered to get hold of a copy, but imagining that it might hold an answer to the question now obsessing me, I went ahead and ordered one. The memoir would surely tell us all about the time she spent nursing her uncle, and if she was indeed the companion we see in Guitry's film, wasn't it possible that she would say something about that too?

While waiting for her memoir to arrive, I searched on-line for more information about Jeanne Fevre. I had hoped to discover when she was born, so that I could work out how old she was in 1915; I'd also hoped to discover an image of her, something with which I could make a visual comparison. Try as I might, though, I could find nothing – no biographical information, and no photographs or artistic representations. Still, I persisted, and was eventually rewarded with something wholly unexpected: a page on the Musée d'Orsay's website which displays eight photographs of the elderly Degas in bed. I had seen some of these photos before, and been moved by them.

43

But what seized my attention were the photographs' credits, which tell us that all eight were taken by Jeanne Fevre, and taken "vers 1915". So, Jeanne Fevre was definitely with her uncle at No. 6 boulevard de Clichy at around the time Guitry captured the old man and his companion on film. And the intimate nature of these photographs – taken at a time when Degas was reluctant to see people, even old friends – strongly suggests that she wasn't simply paying him a visit but was already acting as his carer.

A couple of weeks later, *Mon Oncle Degas* arrived, and I went straight to the last chapter, "Les Dernières Années", hoping to find something conclusive. I was dismayed to find that Fevre says nothing

at all about her time as Degas's carer, but on her book's ante-penultimate page there was a greatly compensating mention of how, in his last years, Degas would respond to requests for interviews:

> To journalists looking for an interview, Degas invariably responded as he rather sharply did to Sacha Guitry, who had come to make a film: "I have absolutely nothing to say to you. I do not know you!"[44]

Would Fevre have quoted Degas's words like this had she not been present when Guitry came calling? I couldn't be sure, of course – she might have been remembering what Degas or Zoé told her some time after the event – but I was more and more convinced that Fevre and the companion were one and the same person. Where else to look for supporting evidence, though? The next obvious place to look was in the literature on Cassatt, she whose idea it had been to install Fevre in the boulevard de Clichy when it became obvious that the old man was in need of more than a housekeeper.

What I found when I obtained a copy of Nancy Mowll Mathews's *Mary Cassatt: A Life* confirmed what I'd suspected, which was that Fevre had definitely taken up her mantle as the artist's carer in 1915:

> Thanks to [Cassatt's] intervention, [Degas's] niece, Jeanne Fevre, had been his nurse for the last two years of his life … By 1914 he had trouble recognizing his friends, although he did attend Cassatt's Paris exhibition of 1914. Soon afterward Jeanne Fevre came to stay with him.[45]

Mowll Mathews doesn't identify a source for this claim, but I found it in another volume for which she'd been responsible – *Cassatt and Her Circle: Selected Letters*. Writing to the art collector Louisine Havemeyer on October 2nd 1917, just two days after Degas's death, Cassatt says:

> Of course, you have seen that Degas is no more. We buried him on Saturday a beautiful sunshine [sic],

a little crowd of friends and admirers, all very quiet and peaceful in the midst of this dreadful upheaval of which he was barely conscious. You can well understand what a satisfaction it was to me to know that he had been well cared for and even tenderly nursed by his niece in his last days. When five years ago I went to see them in the South, and told them what the situation was, his unmarried niece hesitated about going to see him, afraid he might not like her to come, but I told her she would not be there a week before he would not be willing to part with her, of course she found this true, and now for two and a half years she has never left him. She was at the hospital in Nice and had training enough to know just how to nurse her Uncle …[46]

The first thing to impress me about this letter was Cassatt's specificity. Mowll Mathews had spoken rather loosely about the length of time Fevre had cared for her uncle – was it during the last two years of his life or not long after Cassatt's Paris exhibition, which had been held all of three and a half years before his death?[47] – but Cassatt herself is much more precise, stating that Fevre had looked after her uncle for the "two and a half years" leading up to his death. If we took this statement literally, we'd be able to conclude that Fevre moved to Paris in March of 1915; but of course we cannot be so demanding. The most we can safely say is that Fevre had begun caring for her uncle in the spring or early summer of 1915, i.e. right around the time I've been suggesting Guitry obtained his bit of film.[48]

This was a big step forward, but there was an equally big one still to be had, for according to Cassatt, the two and a half years that Fevre looked after Degas were two and a half years in which she "never left him". Had she not told Havemeyer this, all we could have said was that Jeanne Fevre was around at the time, just like Zoé Closier. But if it's true that Fevre never left her uncle, the probability that it is her we see in *Ceux de chez nous* is greatly increased.

If only I could find out when Fevre was born, or what she looked like, the issue might be put beyond reasonable doubt. But how to do

that? The answer to this was nearer to hand than I initially realized. I already knew from his biography that Jeanne's mother Marguerite had been born in 1842, but McMullen had not troubled to tell us when she had married, making any guesses about her daughter Jeanne's age all but impossible. During my on-line search, however, I discovered that her wedding had taken place in 1869, and this allowed me to narrow things down, concluding that Jeanne was likely to have been aged between 33 and 46 at the time Guitry made his film.[49]

I was still unable to find an image of Fevre, but images of her mother and some of her siblings proved easier to locate. One image in particular caught my eye – a photograph taken of Marguerite in 1862 when she was 20:

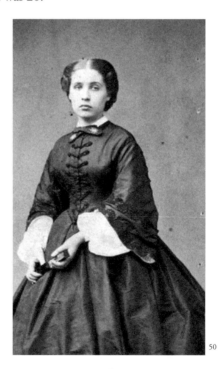
50

While it has to be admitted that the film stills are somewhat blurry,

so that any direct comparison of the 20 year old Marguerite with Degas's companion is difficult, I couldn't help thinking that I saw a resemblance.

Although I thought I'd made a very strong case for saying that Degas's companion was his niece Jeanne Fevre, I still hankered for something more, something that would clinch the matter. I moved a few steps closer when, on a visit to the National Gallery of Art in Washington D.C. in November 2018, I stumbled on a book I hadn't known about, a painstakingly detailed catalogue of the many Degas sculptures that are held by the gallery, one of whose endnotes contains the names and dates of all of the Fevre children, explaining that they were taken from a notarized transcription of Degas's probated will, dated February 28, 1916, which is held in the Musée d'Orsay.[51] It turned out that Jeanne – I now learned that her full name was Marie Fanny Augustine Jeanne – was born on September 26, 1874, which meant she was an obliging 40 years old at the time Guitry took his film.[52] She was the second of eight children born to the Fevres, and the last but one to survive.[53]

The clinching moment came, of course, when I discovered Guitry's own account of what happened the day he went to call on Degas, as narrated in *Le petit carnet rouge*. Here, once more, is the key passage:

> His niece, who was going out with him, told me that there was nothing to do. She said, "No, no, no, do not insist, no, he does not want anything, it's the same with the Légion d'Honneur ..."

This account of Guitry's removed whatever doubt I still had concerning the identity of Degas's companion. It was indeed Jeanne Fevre, and we now know for sure that when she reported Degas's response to Guitry's invitation to appear in *Ceux de chez nous* she was giving eye-witness testimony.

What more can we say about Degas and his niece, now that they have drawn level with the lamppost? It is at this point in the sequence that Fevre appears to spot the lurking camera, and, turning her head in Degas's direction and gesturing with her right hand, she is surely

alerting him to its presence. It is worth noting that she registers no obvious puzzlement or surprise but straightaway issues her warning. Since she was present when Guitry came knocking on the door of No. 6, asking if he could include Degas in *Ceux de chez nous*, she will have instantly understood what was afoot.

Immediately after Fevre has alerted Degas to the camera's presence, another woman comes into view (#29). She is walking away from us, but has allowed herself a very quick look to her right as she passes the camera. All we can say about her is that she has her hair done up in a bun, is wearing a long-sleeved shirt and an ankle-length skirt, and has something – a jacket, perhaps – tucked under her left arm. She is being lightly held by that same arm, and as she moves forward, her companion, who turns out to be another woman (#32), also comes into view. Like the first woman, this second has her hair done up in a bun, wears an ankle-length dress with a white collar and has her waist cinched with a broad cummerbund. Again, we might wonder who these two women are, and where they are going. Could they be *enseignantes*, taking a break from their classes at the Lycée Jules-Ferry? A number of schools have by now been requisitioned, and many of them been turned into hospitals to cope with the returning wounded, but the Lycée Jules-Ferry is not one of them. Indeed, so as to accommodate staff and pupils from schools which have been re-purposed, the Jules-Ferry has been obliged to build a wholly new wing on the Rue de Douai.

As these two women move forward, Degas alters course ever so slightly, not, I think, in order to avoid the camera, but instead to make room for the two women, with whom he might otherwise collide. For her part, the second woman drops back slightly, allowing the first to move ahead. But unlike the first – who has betrayed no interest in the bowler-hatted figure, nor, so far as we can tell, anything but the most cursory in the camera-crew – the second's curiosity has definitely been aroused, and we see her turn to look at the old man, sensing that he is what the film-makers have been waiting for.

We are nearing the end of the sequence, but in the last couple of seconds there is still a lot to observe, not least the brief appearance of three more men. One of the three is visible just to the left of the

65

second woman discussed above (#33–34). He is wearing a pale cloth cap, a lengthy dark jacket, and pale trousers, and is another of those who have decided to avoid the crowded pavement and is walking away from us in the road. Partly obscured by him is the second of the three men, who is wheeling a bicycle from the central reservation to the north side of the boulevard (#34–36). He is wearing a dark jacket and pale trousers, and has what looks like a beret on his head.

I shall come back to the last of the three men in just a moment, after dealing with the other figures I think I can make out just before he steps into view. At this distance, it's impossible to be sure, but I think I can see two women on the central reservation, and at their feet a small white dog (or is it a bag?). The last of the three men to appear in these dying moments is also crossing from the central reservation to our side of the boulevard, but he seems to be out for a stroll rather than intent on getting somewhere, since his footsteps are unhurried and he walks with his hands clasped behind his back. Like the very first man we spotted crossing the road – and who has reappeared a few steps behind the advancing Degas – he has on a dark suit and tie, but he is wearing a homburg, not a flat cap.

Two more things that happen in these last moments should be noted here. To begin with, the woman with a child on her hip makes a fleeting reappearance. She is half-hidden by the man in the homburg, but has ceased walking along the central reservation and is also trying to cross to our side of the boulevard. Is she curious to see what is attracting so much attention, or is she simply obliged to come this way in order to return home?

The second thing I want to note here takes place just as Degas comes between us and the woman and child, for it is at exactly this moment that Fevre reappears – or at any rate, a part of her does. She is reaching out with her left hand, the one with a bag in it, attempting to steer him still further away from the importunate film-maker.

We are almost at the end, but the sequence still has a surprise in store for us, a moment for which I can find no better word than *beatific*. It comes after the young woman who is passing Degas swings round (#40), eager to see what happens when the old man and the camera crew come face to face, for, as she turns, and we register how

beautiful she is, she doesn't simply direct her gaze at the camera but positively beams at it, and in so doing beams at us as well, with the result that, in this briefest of moments, the more than one hundred years which separate us are wholly annulled.

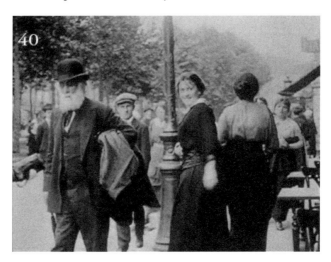

It is a captivating moment, and one that I keep returning to, thrilled and saddened in equal measure.

7

In the last few stills, the young woman is turning away from us (#41–42) and the smile is starting to fade from her face. Will she want to catch up with her companion, to ask her if she has any idea who the bowler-hatted gent was and why someone should have wanted to film him? Or will she recognize that her companion has shown not the least interest – hasn't even looked back to see why they aren't any longer arm in arm – and think better of it?

The young man in the suit and tie is still coming our way, as are the four women whose approach we've been aware of from very early on (#41–42), but the young man is clearly aware of the camera

and is looking directly at it, while the four women – still wondering what it was that had caught and held the attention of the man on the *triporteur*, perhaps – have yet to spot it.

To keep Degas in view for as long as possible, the camera crew are having to pan to the left, but either because they can pan no further, the camera on its tripod being too unwieldy, or else because the old man is so pointedly denying them the pleasure of an acknowledging glance, they are about to abjure their rough magic, and stop filming. As they do so (#42) the pageant fades, and all of the many people we have been privileged to watch and to wonder about are melted into air, leaving not a rack behind.

AFTERWORD

Why have I spent so much time discussing this nine-second film sequence? Does it matter where it was filmed, or when? Who cares what Degas is doing, or is bothered about the identity of his companion? And isn't what I have to say about the other people featured nothing more, for the most part, than idle speculation?

There is a wonderful passage in Thomas Carlyle's 1832 review of John Wilson Croker's edition of Boswell's *The Life of Samuel Johnson, LLD*. It occurs towards the end of his lengthy and carefully considered notice, after he quotes from an entry in Boswell's journal for July 28, 1763 which reads as follows:

> As we walked along the Strand to-night, arm in arm, a woman of the town accosted us in the usual enticing manner. "No, no, my girl," said Johnson; "it won't do." He, however, did not treat her with harshness; and we talked of the wretched life of such women.[54]

We could easily pass from this brief entry to the next, not giving the encounter it relates any further thought, but Carlyle is seized by it, and what he says will help me to explain what it is about Guitry's film that seized me, and seizes me still:

> Strange power of *Reality!* Not even this poorest of occurrences, but now, after seventy years are come and gone, has a meaning for us. Do but consider that it is *true;* that it did in very deed occur! That unhappy Outcast, with her sins and woes, her lawless desires, too complex mischances, her wailings and her riotings, has departed utterly; alas! her siren finery has got all besmutched; ground, generations since, into dust and smoke; of her degraded body, and whole miserable earthly existence, all is away; she is no longer here, but far from us, in the bosom of

Eternity, – whence we too came, whither we too are bound! Johnson said, "No, no, my girl; it won't do"; and then "we talked"; and herewith the wretched one, seen but for the twinkling of an eye, passes on into the utter Darkness.[55]

Carlyle finds in Boswell's entry a short but powerful reminder of our mortality – a 49-word *memento mori* – one which excites in him the need to say rather more, drawing on what he knows or can imagine, and, by way of some expressive writing –

Strange power of *Reality!*

Do but consider that it is *true;* that it did in very deed occur!

… all is away … no longer here, but far from us, in the bosom of Eternity, – whence we too came, whither we too are bound!

– building to that splendid if rueful climax:

… seen but for the twinkling of an eye, passes on into utter Darkness.

I find the very same reminder in Guitry's film – we might with equal justice call it a nine-second *memento mori* – and it is this which excited in me the need to say something more, drawing on what I was able to establish or could plausibly conjecture.

MORE STILLS FROM CEUX DE CHEZ NOUS

André Antoine

Sᴀᴄʜᴀ Gᴜɪᴛʀʏ with Sᴀʀᴀʜ Bᴇʀɴʜᴀʀᴅᴛ

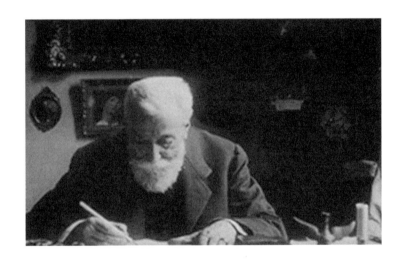

Anatole France

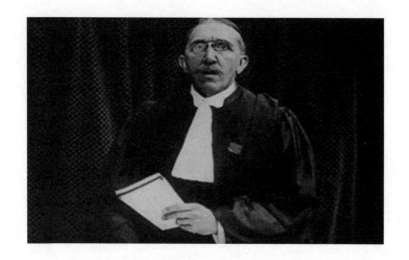

HENRI-ROBERT

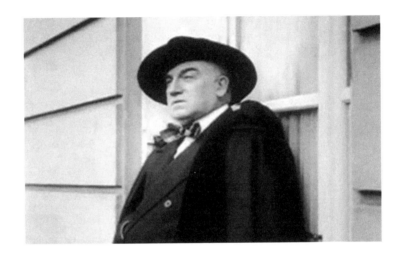

LUCIEN GUITRY

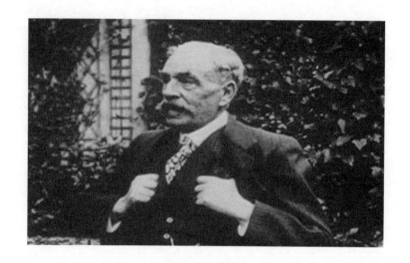

OCTAVE MIRBEAU

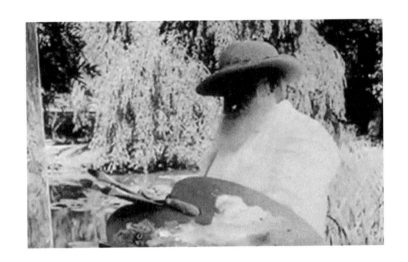

CLAUDE MONET

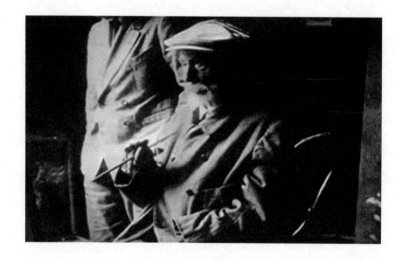

AUGUSTE RENOIR

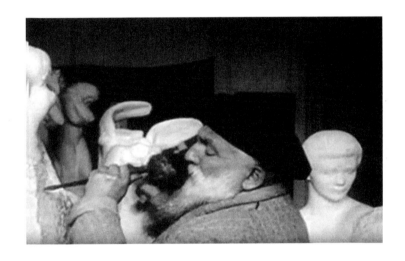

Auguste Rodin

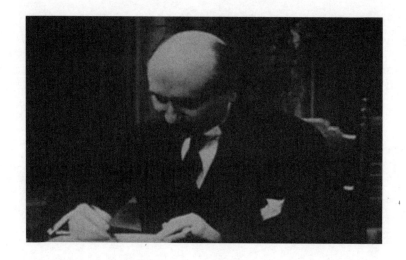

EDMOND ROSTAND

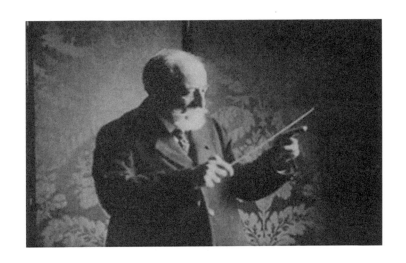

CAMILLE SAINT-SAËNS

PLAYBILL FOR THE PREMIERE OF
CEUX DE CHEZ NOUS, NOVEMBER 22, 1915

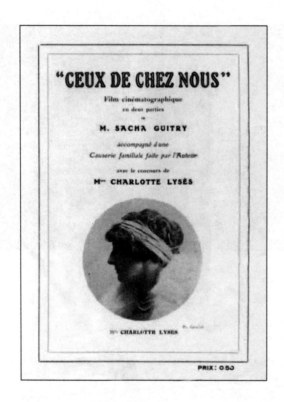

NOTES

1 Alexandre-Pierre Georges "Sacha" Guitry, 1885–1957.
2 The 1952 version of *Ceux de chez nous* can be found at https://www. youtube.com/watch?v=4SEY6AK7RDo. This ends with a sequence not included in the original, one devoted to Guitry's late father, the highly respected actor, Lucien Guitry.
3 Roy McMullen, *Degas: His Life, Times, and Work* (London: Martin Secker & Warburg Ltd, 1985).
4 James Harding, *Sacha Guitry: The Last Boulevardier* (London: Methuen, 1968).
5 Harding, p. 76.
6 The contents of this manifesto and a list of its ninety-three signatories, can be found at: https://en.wikipedia.org/wiki/Manifesto_of_the_Ninety-Three#Signers
7 *Les Fiches de Monsieur Cinéma: Histoire Illustrée du Cinéma Mondial*, Série N° 337.
8 *Ibid.*
9 Harding, p. 79.
10 Harding, p. 78.
11 A list of Harding's many books, including his biographies, is included in the *Guardian* newspaper's obituary, published on October 31, 2007, and available on-line at: https://www.theguardian.com/news/2007/oct/31/guardianobituaries.obituaries1
12 McMullen, p. 388.
13 Alex Madis, *Sacha* (Paris: Editions de l'Elan, 1950), pp. 265–266.
14 Henri Loyrette, *Degas* (Paris: Librairie Arthème Fayard, 1991), pp. 667–669. The translation given here is my own.
15 Sacha Guitry: *Le petit carnet rouge et autres souvenirs inédits* (Paris: Librairie Académique Perrin, 1979), pp. 105–[145].
16 I am assuming, of course, that we are still on the north side of the boulevard, but we have been given no reason – either by Guitry or by Harding – to believe that this assumption is unjustified.
17 If it seems odd that the same company should have had two show-

rooms less than a kilometre apart, and on the very same boulevard, it should be borne in mind that it had been founded in 1860, had won numerous prizes for what it advertised as "les veritables pian-os", and by 1900 was selling more than 1,000 of them each year.

18 Degas used the Café de la Nouvelle Athènes as the setting of another of his most famous paintings, *L'Absinthe*, painted in the mid-1880s.

19 Towards the end of 1915, Degas's health took a turn for the worse, and the Café de la Nouvelle Athènes and Le Rat Mort will have been the only cafés he still had the strength to walk to. Degas's brother René was visiting him on a weekly basis during this period, and on November 17 wrote to his sibling's old friend and dealer, Paul Lafond, as follows: "Thank you for your interest in the health of dear Edgar. Unhappily, I cannot tell you anything encouraging ... When he goes out, he can hardly walk farther than Place Pigalle; he spends an hour in a café and returns painfully..." Quoted in Jean Sutherland Boggs's *Degas* (New York: The Metropolitan Museum of Art; Ottawa: National Gallery of Canada, 1988), p. 497. Some time in 1916, Degas's health will decline still further, and, the five flights of stairs at No. 6 being too much for him, he will be forbidden even this small pleasure, and have to resign himself to the life of an apartment-bound invalid.

20 See Daniel Halévy, *My Friend Degas* (Middletown, Conn: Wesleyan University Press, 1964), illustration opposite p. 112; McMullen, p. 465; Robert Gordon and Andrew Forge, *Degas* (London: Thames & Hudson, 1988), pp. 38–39; Boggs, p. 497; Loyrette, p. 667.

21 H. Pearl Adam, *Paris Sees It Through: A Diary, 1914–1919* (London, New York, Toronto: Hodder and Stoughton, 1919), p. 57.

22 By the end of 1914, France's recorded losses amounted to 301,000 men. By the end of 1915, a further 349,000 had also perished. It is estimated that by the time Germany capitulated, an average of 900 Frenchmen had lost their lives every day. (See https://encyclope-dia.1914-1918-online.net/article/war_losses_france)

23 Vincent Cronin, *Paris on the Eve: 1900–1914* (London: Collins, 1989), pp. 441–442.

24 Mary McAuliffe, *Twilight of the Belle Epoque* (Lanham, MD: Rowman & Littlefield, 2014), p. 286.

25 "[T]he French army had ridden out defeat in the field, sustained its cohesion, driven the invader from the environs of the capital, won a sensational defensive victory and dictated that a war of entrenchment would be fought not in the heart of the country but at the periphery of the national territory." John Keegan, *The First World War* (London: Pimlico, 1999), p. 148.

26 Adam, pp. 56–57.

27 The words are from Eliot's *Burnt Norton*, the first of his *Four Quartets* (*The Poems of T. S. Eliot*, Vol. I [London: Faber & Faber, 2015], p. 180), but he had first used them in his play, *Murder in the Cathedral* (London: Faber & Faber, 1935), p. 67.

28 As would the unnamed policeman who, when reporting what he'd witnessed on the streets and in the cafés of Paris, wrote about "un besoin de se griser, d'oublier" ["a need to get drunk, to forget"]. Report of 15 December 1915, Archives de la préfecture de Police, BA, 1587, as cited in Jan Rüger, "Entertainments", in eds. Jay Winter and Jean-Louis Robert, *Capital Cities at War: Paris, London, Berlin 1914–1919: Volume 2: A Cultural History* (Cambridge: Cambridge University Press, 2007), p. 133, and fn. 98.

29 Emmanuelle Cronier, "The Streets", in eds. Winter and Robert, p. 88.

30 Cronier, in eds. Winter and Robert, p. 87.

31 Like most other European countries of the time, France employed universal conscription, requiring men aged between 20 and 23 to serve in the Active Army, men aged between 24 and 34 to serve in the Reserve of the Active Army, men aged between 35 and 41 to serve in the Territorial Army, and men aged between 42 and 48 to serve in the Reserve of the Territorial Amy.

32 Meaning "hairy one".

33 I have not allowed for the possibility that he might have been opposed to fighting because France did not recognize conscientious objection until 1963.

34 Adrian Gregory, "Railway Stations: Gateways and Termini", in eds. Winter and Robert, p. 48.

35 Cronier, p. 87.

36 Or perhaps *La Baïonnette*, since *À la Baïonnette*, which was launched in January 1915, was taken over by a new publisher just

six months later, and was distributed thereafter under the abbreviated title.

37 "Keep quiet, beware, enemy ears are listening to you."

38 Photograph courtesy of the Metropolitan Museum of Art, New York, Accession No: 2010.457.4a

39 The photo, showing Mme Fourchy and her husband with Degas at Menil-Hubert c. 1900, is reproduced in Boggs, p. 506.

40 Paul Valéry, *Degas Manet Morisot*, translated by David Paul, with an introduction by Douglas Cooper (Princeton, NJ: Princeton University Press, 1989), Bollingen Series, XLV, p. 21

41 McMullen, p. 464.

42 McMullen, p. 17.

43 Photo credit: RMN-Grand Palais [Musée d'Orsay] / Hervé Lewandowski. It can be found online at: https://art.rmngp.fr/fr/library/artworks?authors-Jeanne%20F%C3%A8vre

44 Jeanne Fevre, *Mon Oncle Degas: Souvenirs et documents inédits recueillis et publiés par Pierre Borel* (Geneva: Pierre Cailler, 1949), p. 142.

45 Nancy Mowll Mathews, *Mary Cassatt: A Life* (New Haven & London: Yale University Press, 1994), p. 312.

46 Mowll Mathews, p. 328.

47 Cassatt's exhibition (*Tableaux, Pastels, Dessins, et Pointes-sèches*) had been held at the Galeries Durand-Ruel between June 8 and 27, 1914.

48 In arguing for Fevre's arrival in Paris having taken place in 1915, I find myself at odds with the distinguished art historian, Professor Theodore Reff, who dates it to 1916. *The Letters of Edgar Degas*, edited and annotated by Theodore Reff (New York: The Wildenstein Plattner Institute, Inc., 2020), Vol. 3, p. 334. I don't know what led Professor Reff to this conclusion, or how he thinks it can be squared with the countervailing evidence adduced in this essay.

49 I am assuming, of course, that Jeanne was not born out of wedlock and that Marguerite was past childbearing age by the time she turned 40.

50 Photo credit: RMN-Grand Palais [Musée d'Orsay] / Hervé Lewandowski. This photograph was taken by Pierre Lanith Petit (1832–1909, and can be found online at: https://www.photo.rmn.fr/archive/02-001264-2C6NU0GSIFOH.html

51 See Susan Glover Lindsay, Daphne S. Barbour and Shelley G. Sturman's *Edgar Degas Sculpture* (Princeton: Princeton University Press, 2011), p. 20, n. 1.

52 She died, aged 77, two years after publication of *Degas Mon Oncle*, on June 5, 1951.

53 There seems to be some confusion about the number of children born to Marguerite and Henri Fevre. Writing about the family in 1881, McMullen speaks of "Marguerite's five children" (McMullen, p. 349), but as I have just pointed out, the couple had had a total of eight children by then, Jeanne's seven other siblings being Juliette Marie Célestine (April 17, 1866–November 1908), Marie Thérèse Anne (April 17, 1866–1917), Marie Léonie Adille (February 12, 1870–June 1881), Eugène Marie Edgard Gabriel (February 1, 1872–November 3, 1933), Simonne Célestine Marguerite Marie (October 6, 1875–November 26, 1880), Pauline Marie Madeleine (October 23, 1876–June 3, 1960), and Henri Jean Auguste Marie (c. 1878–after 1931). Even if McMullen meant to be speaking about the number of Fevre children who were still alive in the summer of 1881, there weren't only five of them, there were six or seven, depending on whether we include Marie Léonie Adille, who died that June.

54 In fact, Carlyle has slightly truncated Boswell's entry, lopping off a continuation of its last sentence, which, following a semicolon, reads: "and agreed, that much more misery than happiness, upon the whole, is produced by illicit commerce between the sexes." See *James Boswell, The Life of Samuel Johnson*, edited with an introduction by David Womersley (London: Penguin, 2008), p. 240.

55 *Fraser's Magazine for Town and Country*, No. XXVII, Vol. V, April 1832, pp. 253–260 [p. 258]. The whole review can be read at: https://hdl.handle.net/2027/mdp.39015008227541?urlappend=%3Bseq=265%3Bownerid=13510798895974502-273mdp.39015008227541?urlappend=%3Bseq=265%3Bownerid=13510798895974502-273

A NOTE ABOUT THE AUTHOR

Philip Hoy was born in London in 1952, and educated at the Universities of York and Leeds. He has a Ph.D in Philosophy, a subject he taught most recently for the University of Oxford's Department for Continuing Education.

Prior to founding The Waywiser Press, in 2002, Hoy joined forces with Peter Dale and Ian Hamilton and founded Between The Lines, a publishing house specializing in book-length interviews with senior contemporary poets. The three were subsequently joined by the editor of *The Yale Review*, J. D. McClatchy.

Hoy is the editor of *A Bountiful Harvest: The Correspondence of Anthony Hecht and William L. MacDonald* (Waywiser, 2018), and his previous publications include *W. D. Snodgrass in Conversation with Philip Hoy* (Between The Lines, London, 1998), *Anthony Hecht in Conversation with Philip Hoy* (Between The Lines, London, 1999, 2001, 2004), and *Donald Justice in Conversation with Philip Hoy* (Between The Lines, London, 2001).

A limited fine press edition of Anthony's Hecht's last poems, *Interior Skies: Late Poems from Liguria*, for which Hoy wrote the foreword, was published in 2011 by Liv Rockefeller and Kenneth Shure's Two Ponds Press.

Hoy's one-volume edition of Anthony Hecht's *Collected Poems* is forthcoming from Knopf / Random House.

Hoy lives with his wife, the violinist Philippa Ibbotson, in rural West Oxfordshire.

ACKNOWLEDGMENTS

I should like to thank the following people for their helpful and encouraging responses to this essay: Julian Barnes, Neil Berry, Nicholas Garland, Joseph Harrison, Kate Hollander, George Huxley, Philippa Ibbotson, Gabriel Josipovici, Jean McGarry, Sam Milne, Philip Morre, Joe Osterhaus, Jonathan Post, John Rosenthal, Miranda Seymour, Alan Shapiro, Henry Walters, David Wasserstein, and Stephen Yenser.

OTHER BOOKS FROM WAYWISER

Other Books from Waywiser

Bradford Gray Telford, *Perfect Hurt*
Matthew Thorburn, *This Time Tomorrow*
Cody Walker, *Shuffle and Breakdown*
Cody Walker, *The Self-Styled No-Child*
Cody Walker, *The Trumpiad*
Henry Walters, *The Nature Thief*
Deborah Warren, *The Size of Happiness*
Clive Watkins, *Already the Flames*
Clive Watkins, *Jigsaw*
Richard Wilbur, *Anterooms*
Richard Wilbur, *Mayflies*
Richard Wilbur, *Collected Poems 1943-2004*
Norman Williams, *One Unblinking Eye*
Greg Williamson, *A Most Marvelous Piece of Luck*
Greg Williamson, *The Hole Story of Kirby the Sneak and Arlo the True*
Stephen Yenser, *Stone Fruit*

FICTION
Gregory Heath, *The Entire Animal*
Mary Elizabeth Pope, *Divining Venus*
K. M. Ross, *The Blinding Walk*
Gabriel Roth, *The Unknowns**
Matthew Yorke, *Chancing It*

ILLUSTRATED
Nicholas Garland, *I wish ...*
Eric McHenry and Nicholas Garland, *Mommy Daddy Evan Sage*
Greg Williamson, *The Hole Story of Kirby the Sneak and Arlo the True*

INTERVIEWS
John Ashbery in Conversation with Mark Ford
Peter Dale in Conversation with Cynthia Haven
Thom Gunn in Conversation with James Campbell
Michael Hamburger in Conversation with Peter Dale
Donald Hall in Conversation with Ian Hamilton
Seamus Heaney in Conversation with Karl Miller
Anthony Hecht in Conversation with Philip Hoy
Donald Justice in Conversation with Philip Hoy
Charles Simic in Conversation with Michael Hulse
W. D. Snodgrass in Conversation with Philip Hoy
Anthony Thwaite in Conversation with Peter Dale and Ian Hamilton
Richard Wilbur in Conversation with Peter Dale
Seven American Poets in Conversation: John Ashbery, Donald Hall,
Anthony Hecht, Donald Justice, Charles Simic,
W. D. Snodgrass, Richard Wilbur
Three Poets in Conversation: Dick Davis, Rachel Hadas, Timothy Steele

NON-FICTION
Neil Berry, *Articles of Faith: The Story of British Intellectual Journalism*
Irving Feldman, *Usable Truths: Aphorisms & Observations*
Mark Ford, *A Driftwood Altar: Essays and Reviews*
Philip Hoy, ed., *A Bountiful Harvest: The Correspondence of*
Anthony Hecht and William L. MacDonald
John Rosenthal, *Searching for Amylu Danzer*
Richard Wollheim, *Germs: A Memoir of Childhood*

*Co-published with Picador